D1029056

CHATHAM

At Its Best

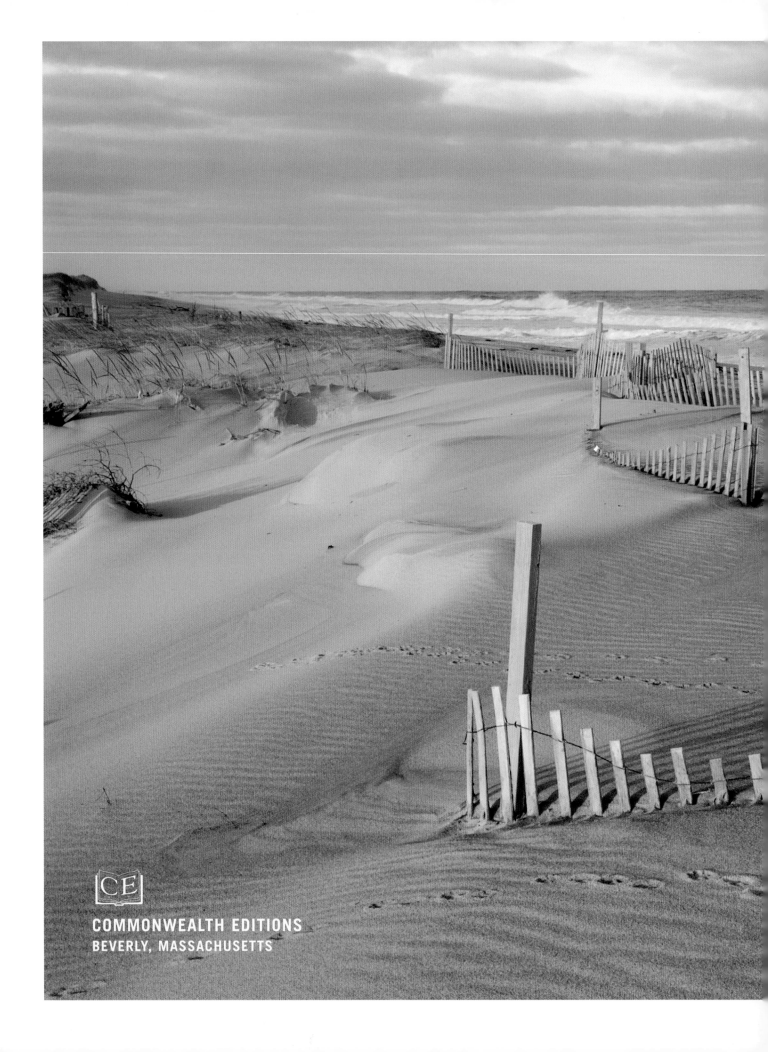

COMMONWEALTH EDITIONS
BEVERLY, MASSACHUSETTS

CHATHAM
At Its Best

PHOTOGRAPHS BY
JENNIFER
ELDREDGE
STELLO

In memory of Josh.
Without your passion and zest for life surring me on,
this wouldn't have happened.

Copyright © 2008 by Jennifer Eldredge Stello

All rights reserved. No part of this book may be reproduced in any form or by any electronic or mechanical means without permission in writing from the publisher, except by a reviewer who may quote brief passages in a review.

ISBN: 978-1-933212-80-7

Cover and interior design by Anne Lenihan Rolland

Printed in Korea

Published by Commonwealth Editions, an imprint of Memoirs Unlimited, Inc., 266 Cabot Street, Beverly, Massachusetts 01915

Visit us on the Web at www.commonwealtheditions.com.

To see more photos by Jennifer Eldredge Stello, visit *www.capephotographs.com.*

Front Cover: *Miss Fitz*
Overleaf (title page): North Beach

10 9 8 7 6 5 4 3 2 1

INTRODUCTION

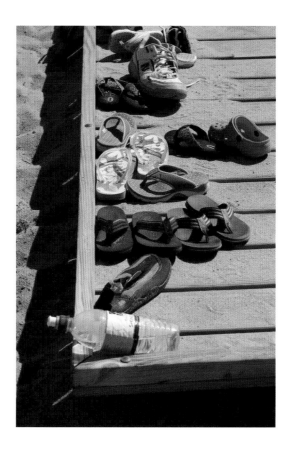

Chatham At Its Best is a compilation of photographs I have chosen from my body of work over the last few years. My focus in this publication is to capture the true essence of community and peacefulness that is the small town of Chatham, Massachusetts. No matter what the season, Chatham holds a certain uniqueness that my family and I have embraced for generations.

It's difficult to pinpoint one specific place or thing that makes Chatham so dear to me. During the last fifty years I have seen numerous changes as the town has developed both architecturally and environmentally, but the charm has magically sustained itself. The pristine beaches, emerald marshes, majestic waterways, and quaint villages continue to lure vacationers from near and far.

Chatham's First Night and annual festivals welcome family fun and a sense of community. Meandering along the sandy shores restores calm that evades our everyday lives. Chatham offers an insight into our soul as it relates to nature.

The camera's lens reveals Chatham's natural beauty. I believe the fresh salty air lingers with you throughout the year. Like the historic Chatham Light, which guides seafarers home from the challenges of the surrounding sea, the Town of Chatham acts as a beacon for residents as well as visitors to return.

I hope you enjoy this first edition of *Chatham At Its Best* and come to love Chatham as I do.

—Jennifer Eldredge Stello

1

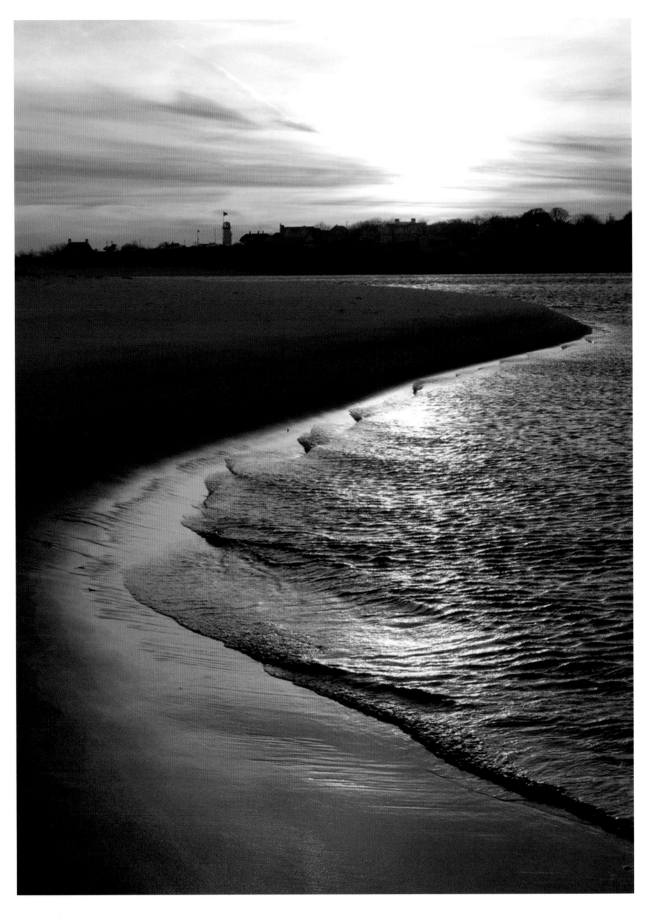

Chatham Light from the tip of North Beach

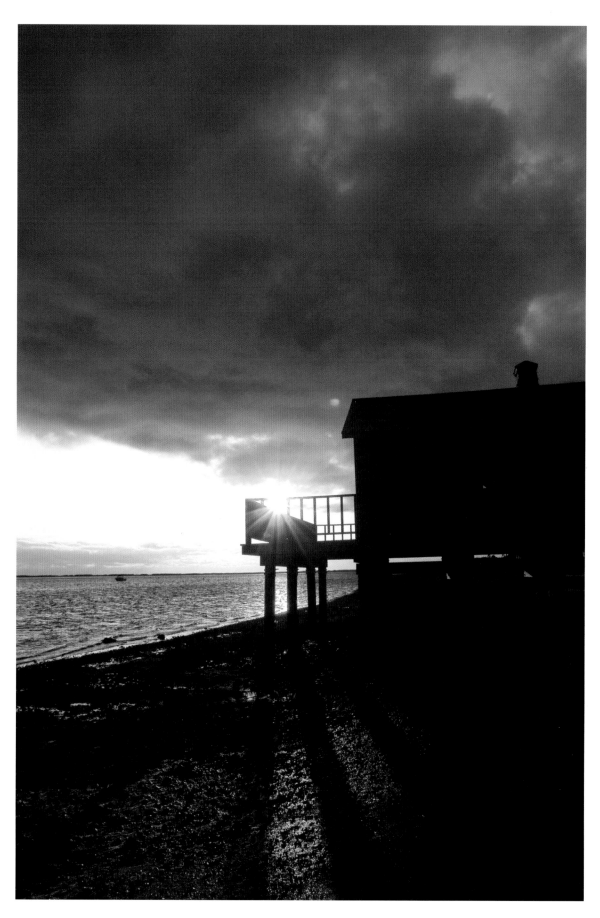

A view of North Beach and a boathouse on the shore of Scatteree Landing.
A severe storm in April 2007 created a cut-through—called the New Break—
that opens the harbor to the ocean across from this point.

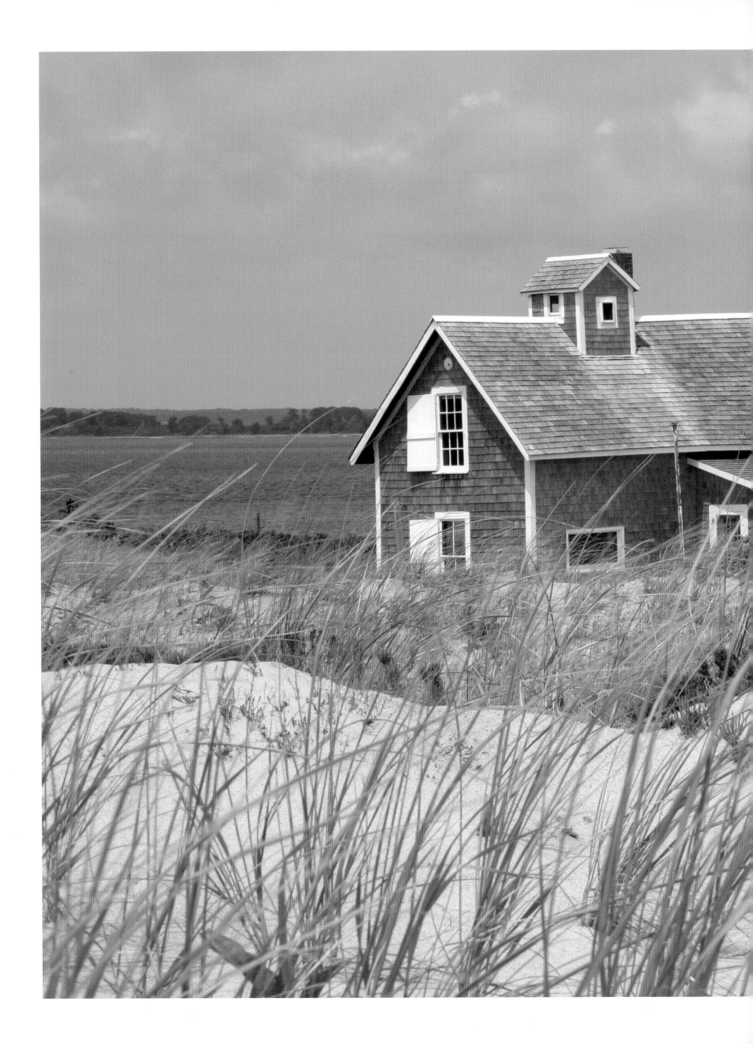

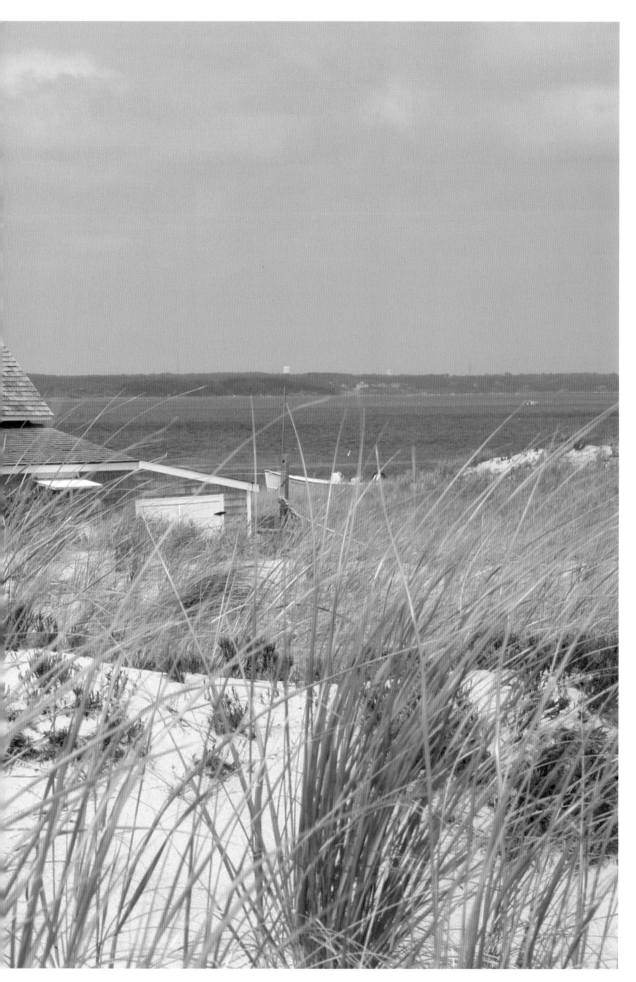

Built in the early 1940s, the Harriss Camp was the oldest on North Beach. It was taken by the sea in December 2007.

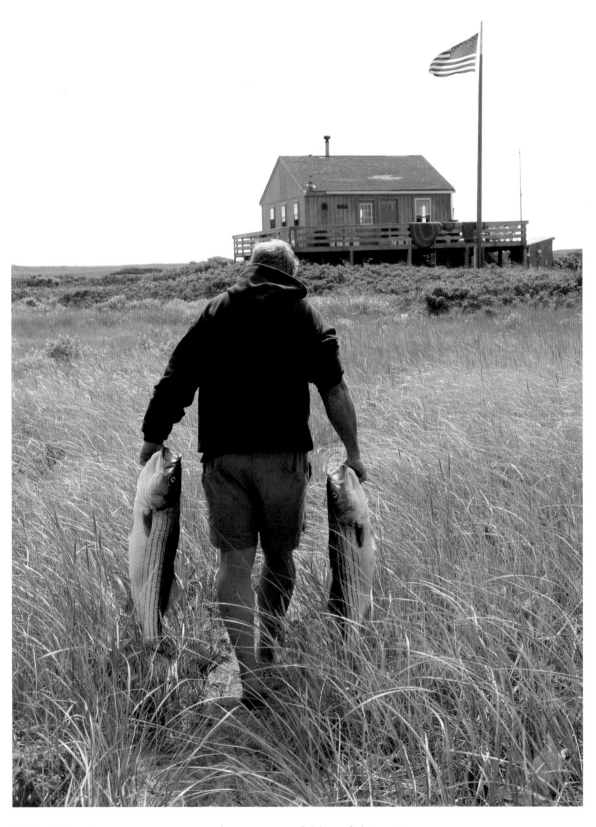

A North Beach camp owner returns from a successful bass-fishing trip.

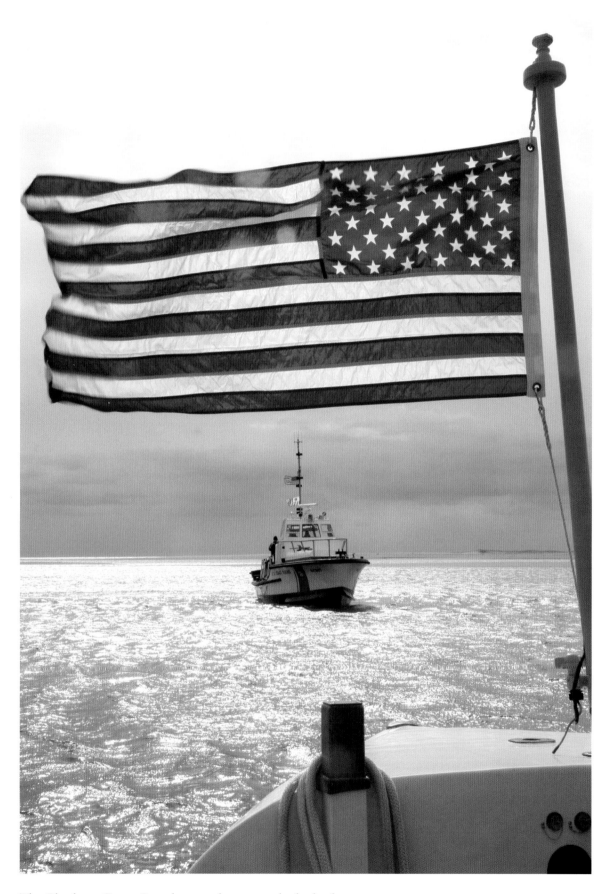

The Chatham Coast Guard rescue boat patrols the harbor.

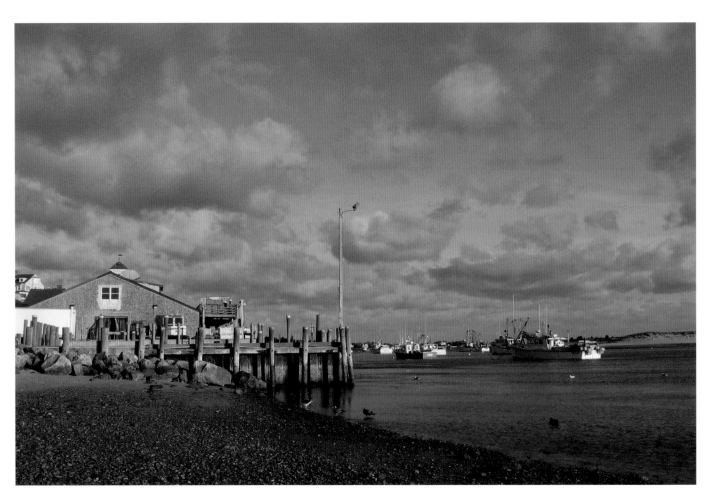

Dead low tide at the Chatham Fish Pier, seen here from the south

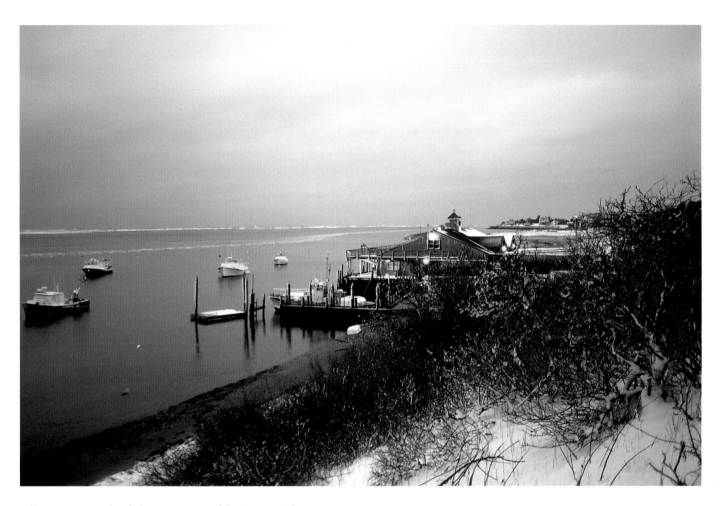

All is quiet on the fish pier on a cold winter night.

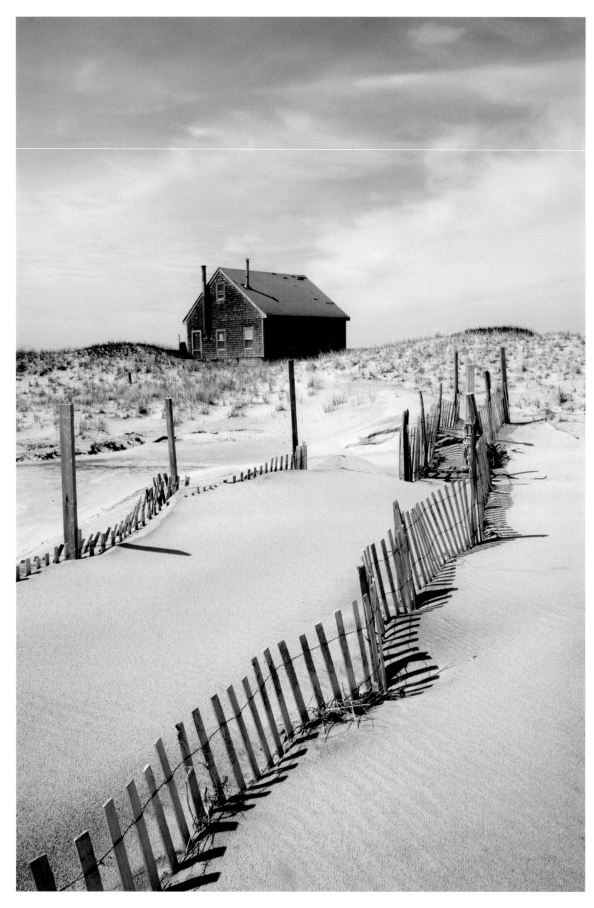

Truelove's camp site, protected by the surrounding dunes. It was removed from the beach in January 2008 because of severe erosion and the New Break.

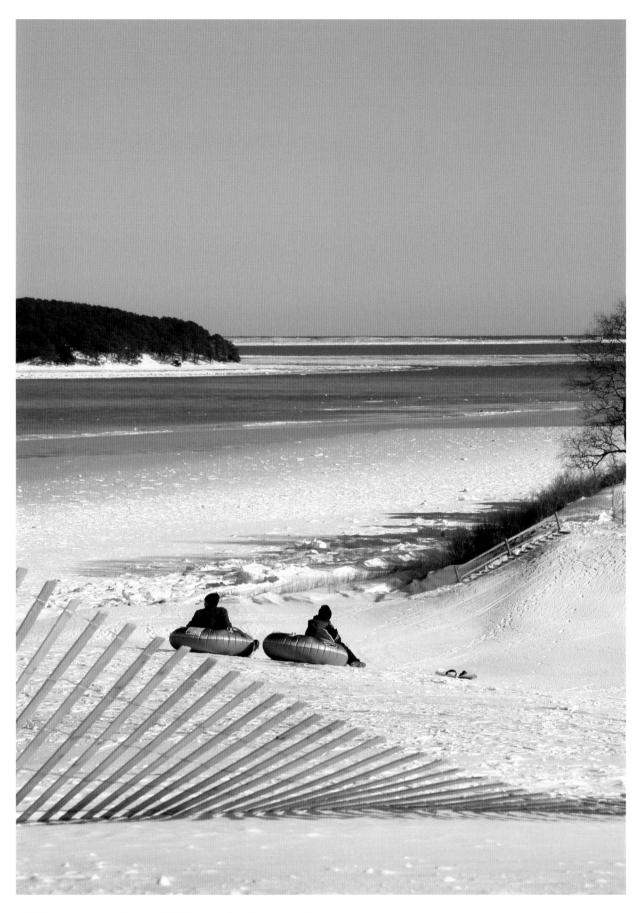

Tubing at Eastward Ho Golf Course has been a winter
pastime for generations.

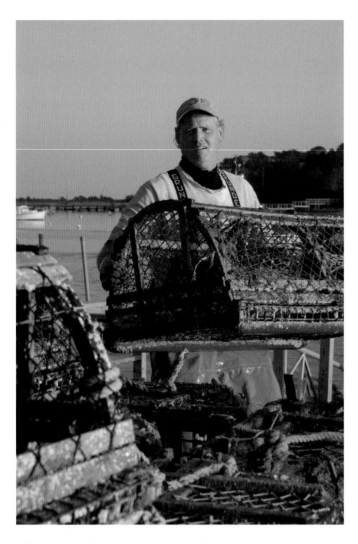

Above: A lobsterman stacks up his pots to end a successful season.

Right: Lobster pots on the dock at Port Fortune Landing in Stage Harbor

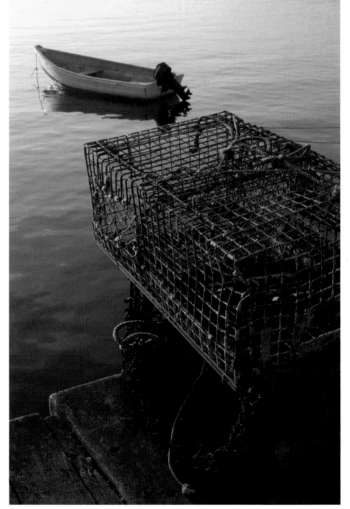

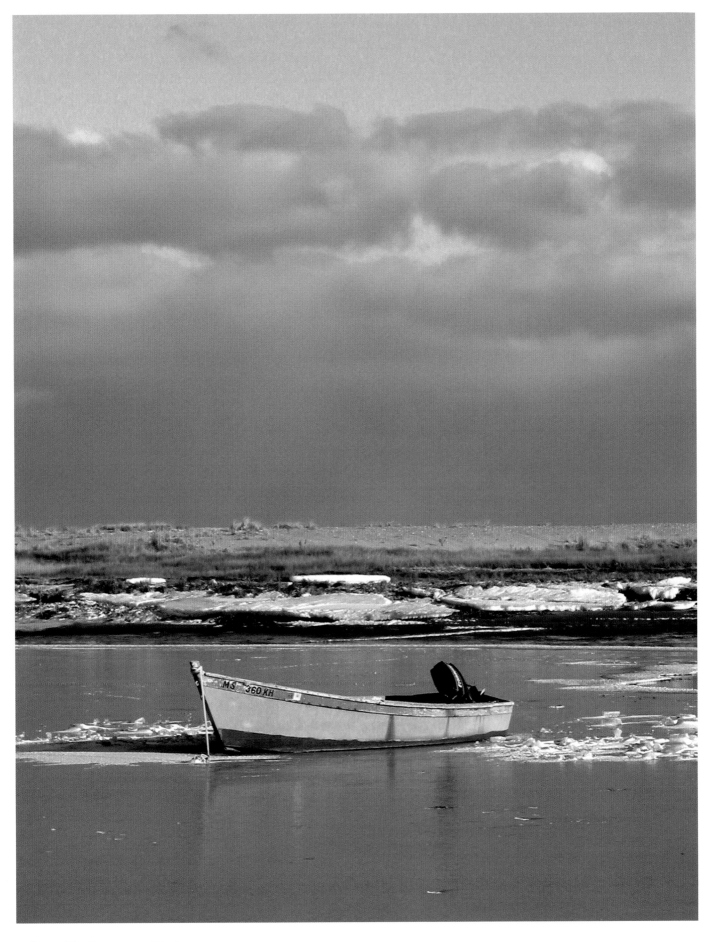

Icebound in Outermost Harbor.

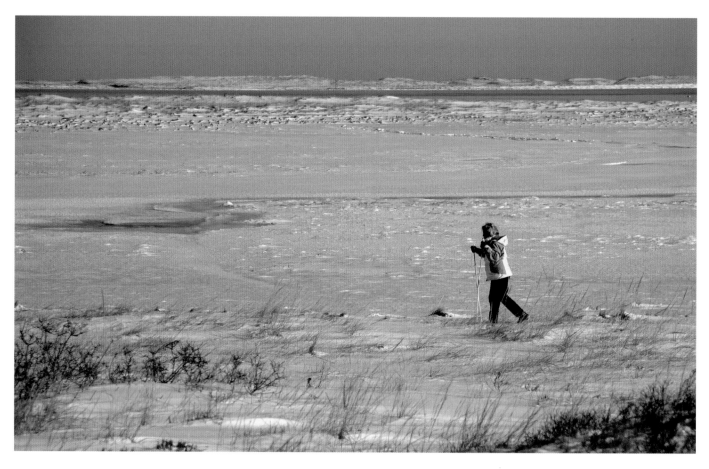

Cross-country skiing at the Stage Harbor Causeway

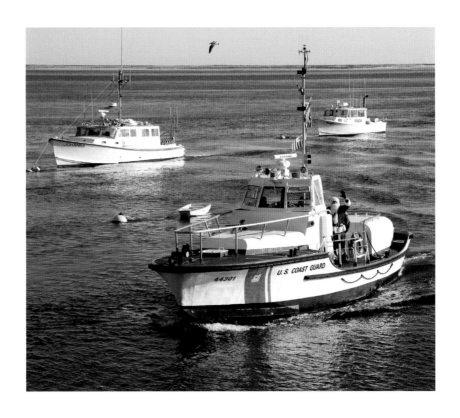

Above: The Coast Guard escorts Santa to the Chatham Fish Pier.

Left: Children greet Santa at his annual visit to the fish pier.

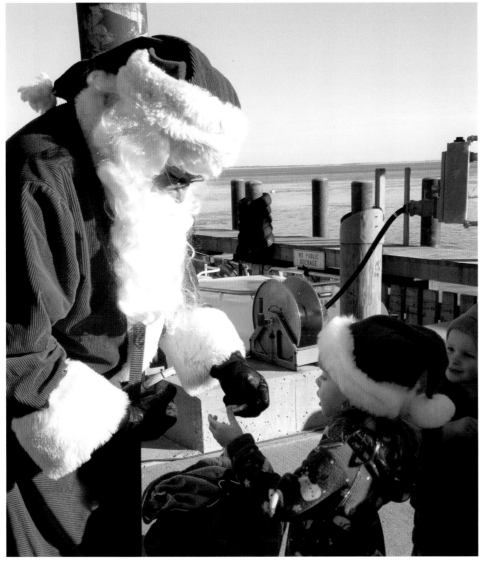

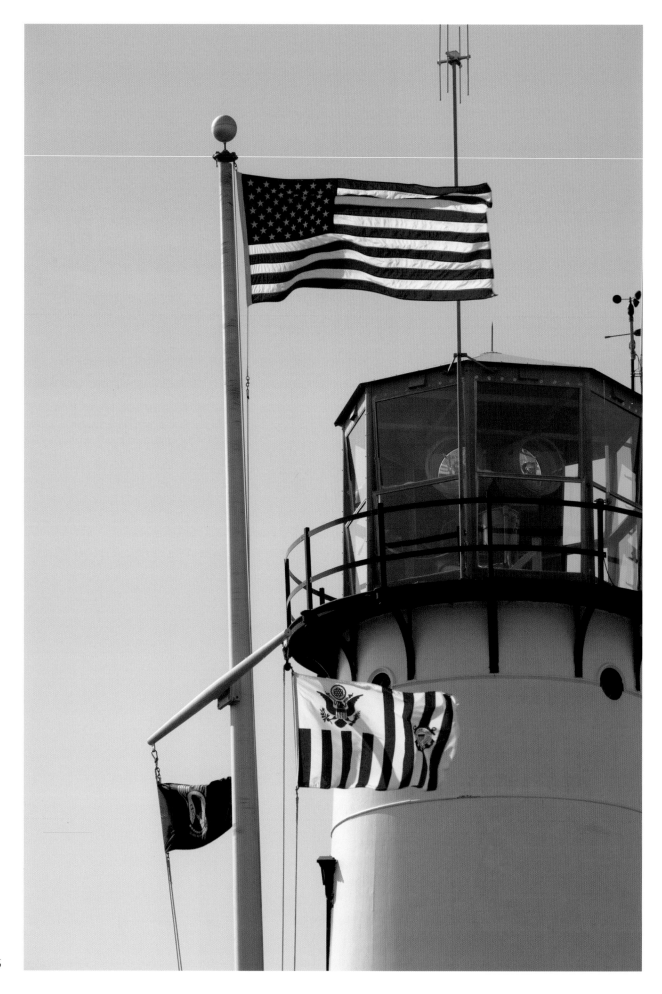

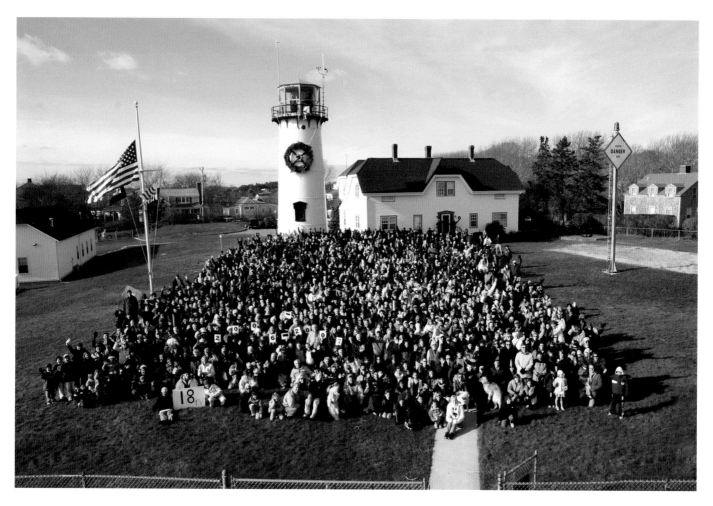

Above: A town photo, taken each year on New Year's Eve, kicks off the First Night celebrations.

Left: The flag at Chatham Light

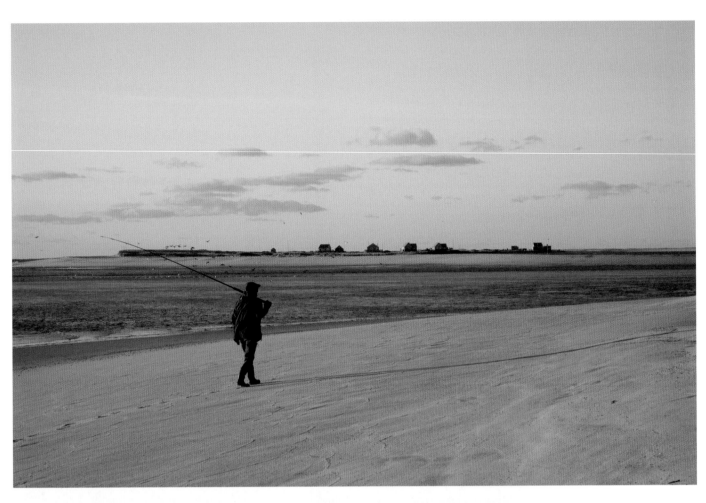

Above: A lone fisherman walks along the shore of Chatham Harbor's New Break, which opened during the nor'easter of April 2007.

Below: Rushing tides bring in fish for these surfcasters at the New Break.

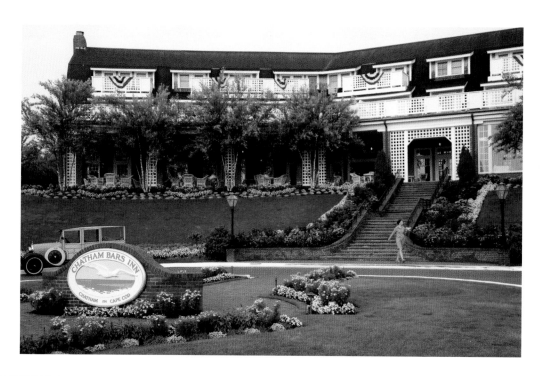

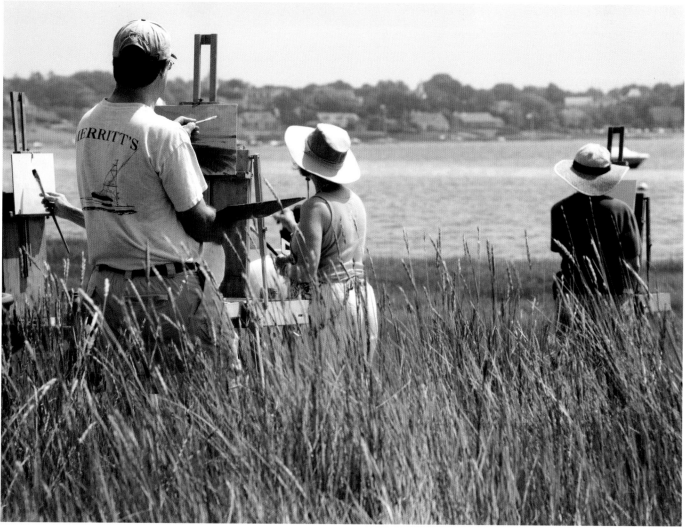

Above: Operating since 1914, the Chatham Bars Inn continues to be an active and popular resort.

Below: The Creative Arts Center hosts its summer *plein air* painting class on the shore of Oyster Pond.

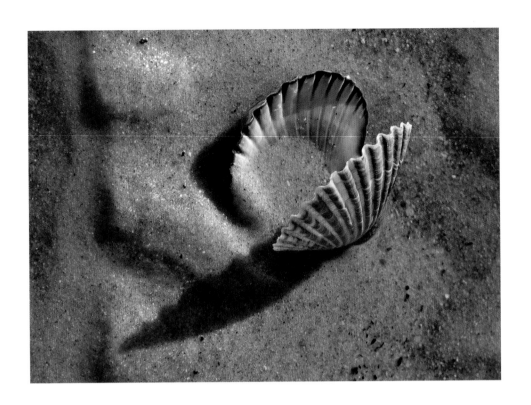

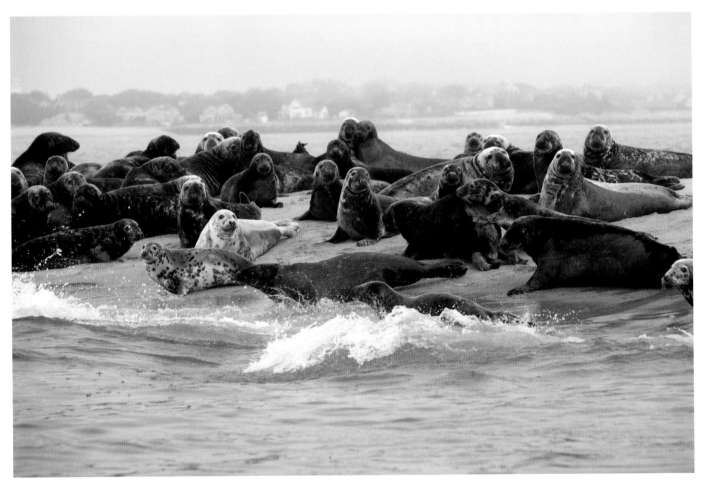

Above: A scallop shell soaks up the sun.

Below: A colony of seals resting on a flat in front of Chatham Light

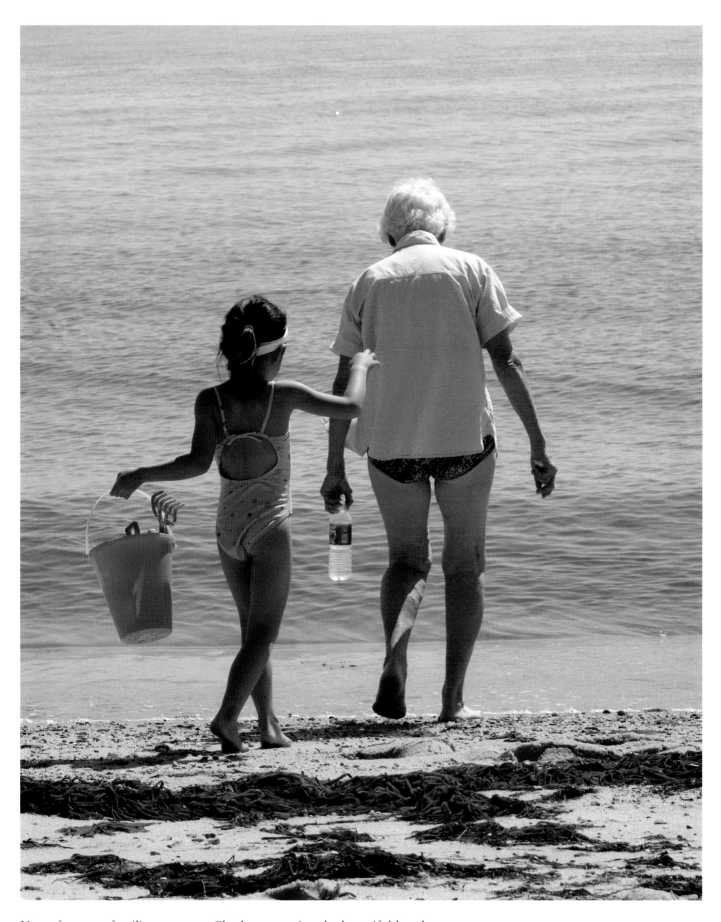

Year after year, families return to Chatham to enjoy the beautiful beaches.

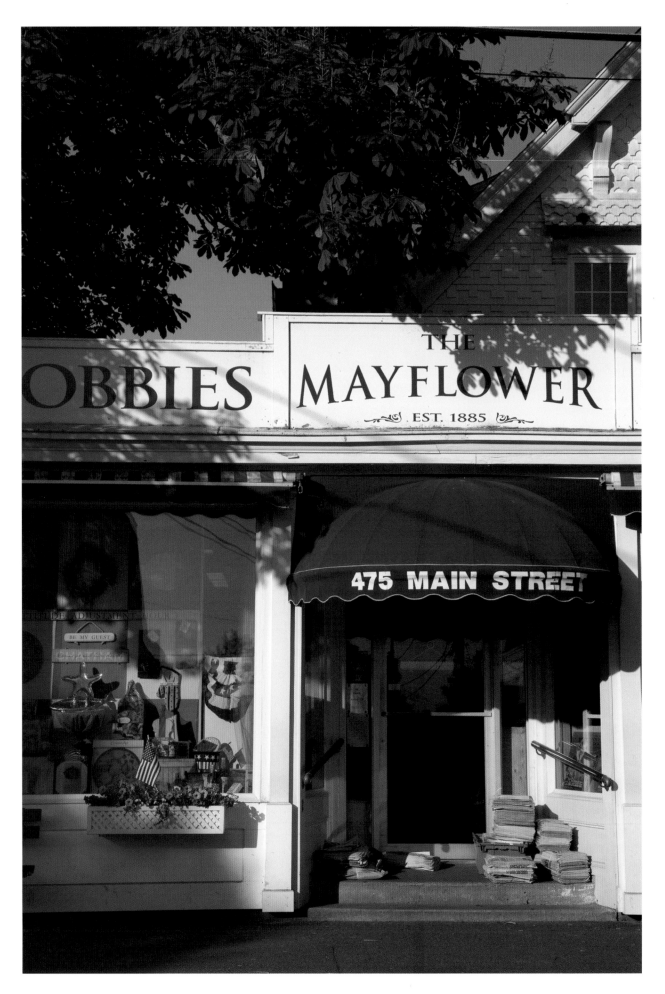

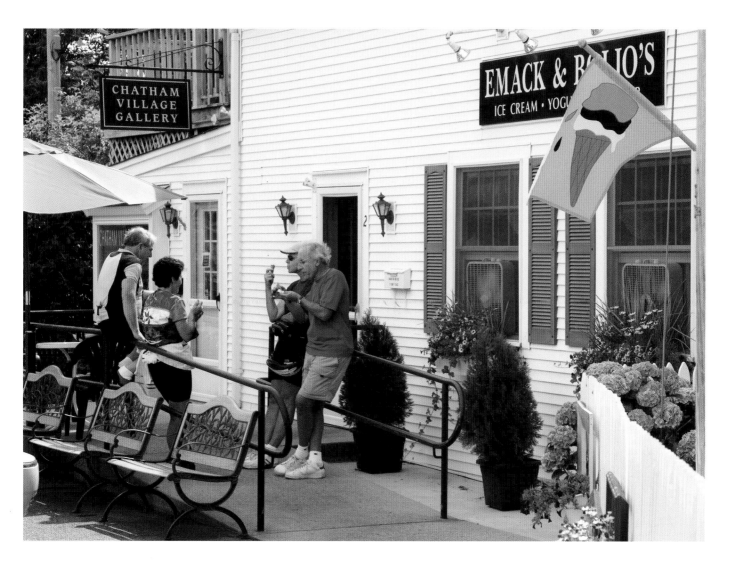

Right: The Chatham Squire is a popular local hangout.

Below: Ice cream is a favorite in the summer.

Left: Daily newspapers await the opening of the shops on Main Street.

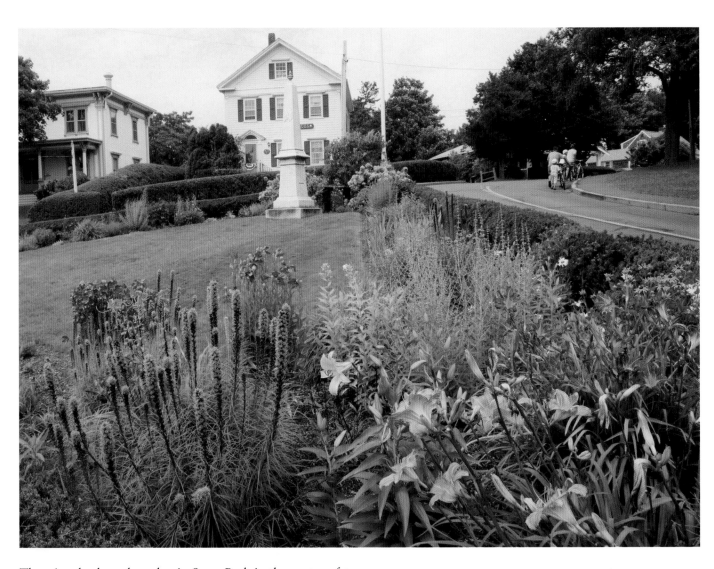

The triangle-shaped garden in Sears Park in the center of town
cascades with color from spring to fall.

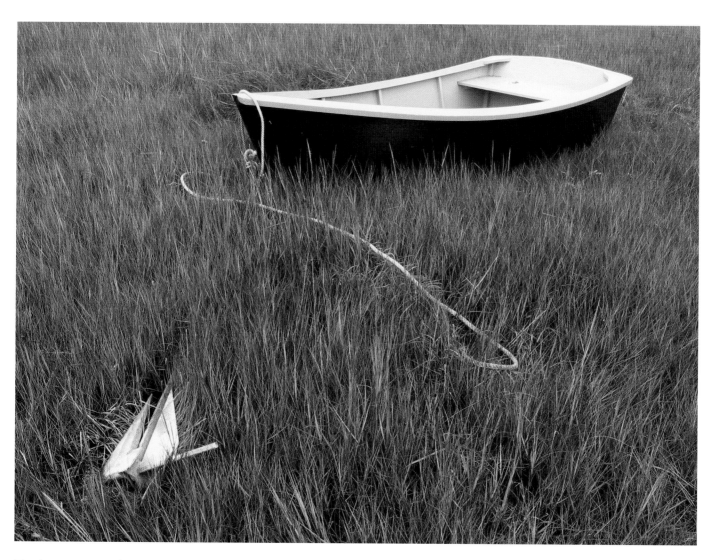

Tender resting in the marsh

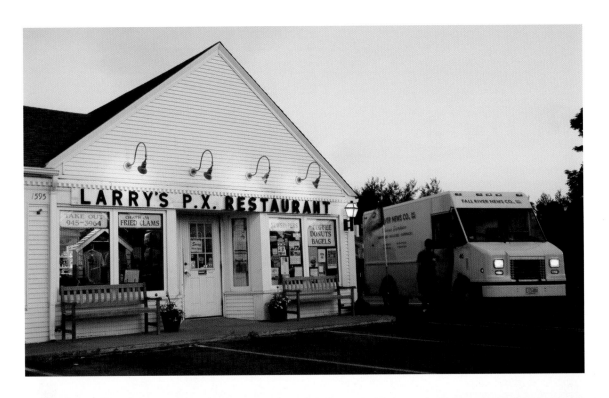

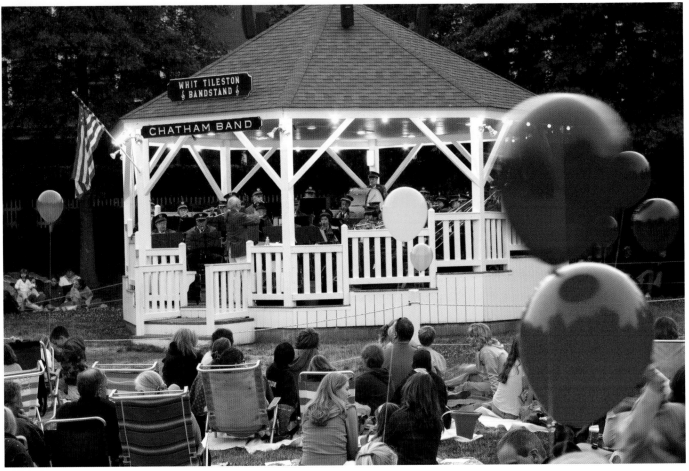

Above: 5:00 A.M. paper delivery

Below: The Chatham band concert is a weekly event during the summer.

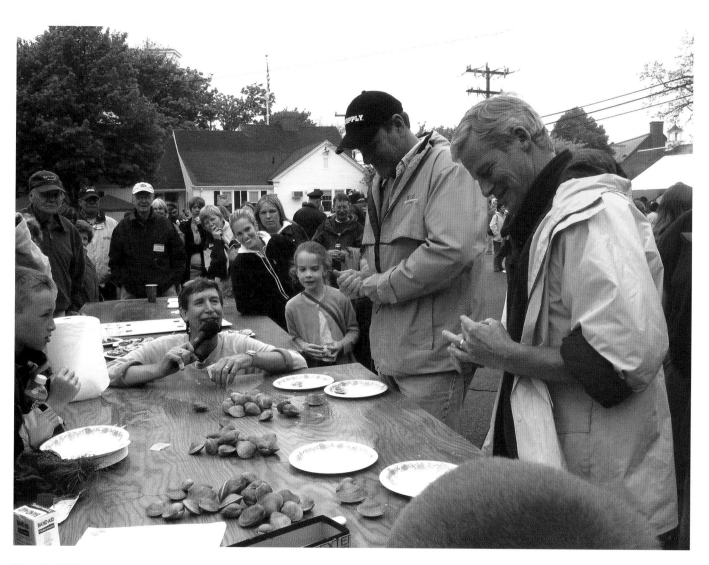

The shellfish-opening contest at the Chatham Maritime
Festival attracts all ages for family fun.

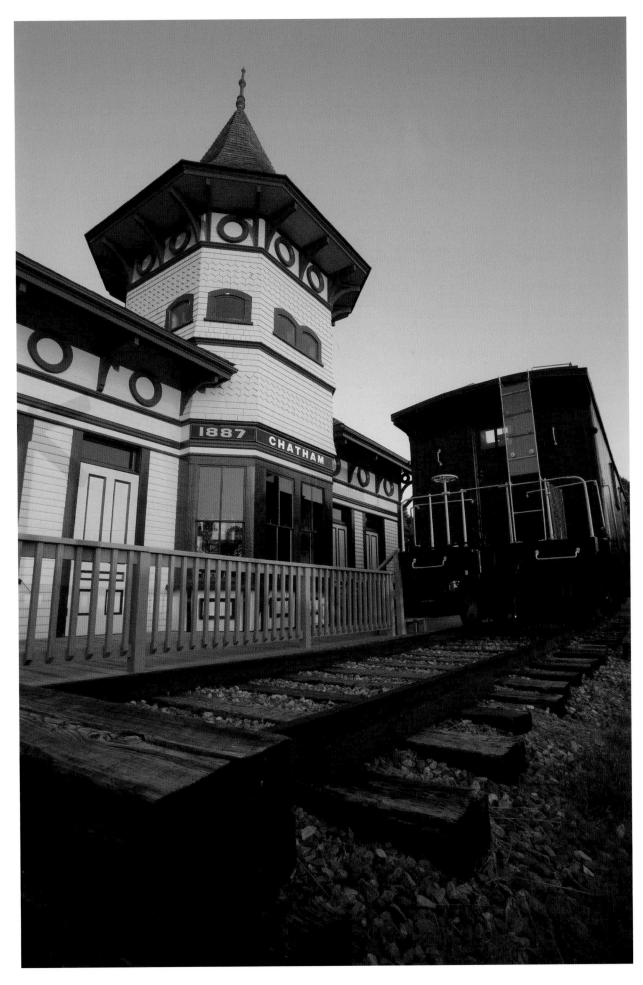

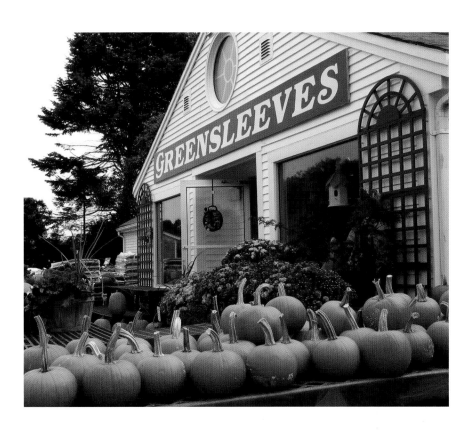

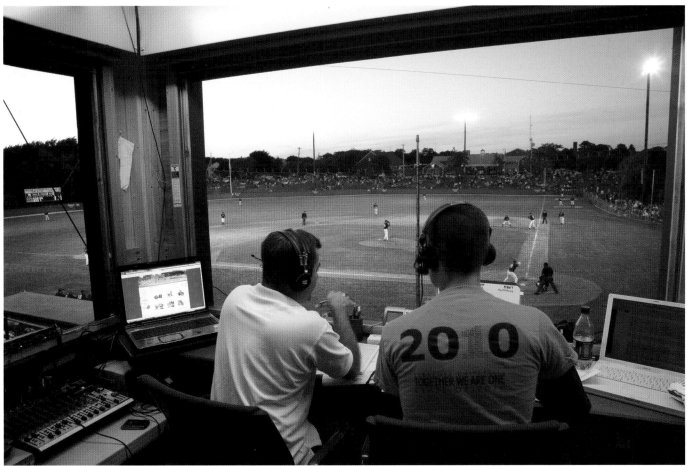

Above: A nursery is colorfully decorated with pumpkins for the fall.

Below: Inside the press box during a Chatham A's baseball game

Left: Chatham's historic train station is now a museum open to the public.

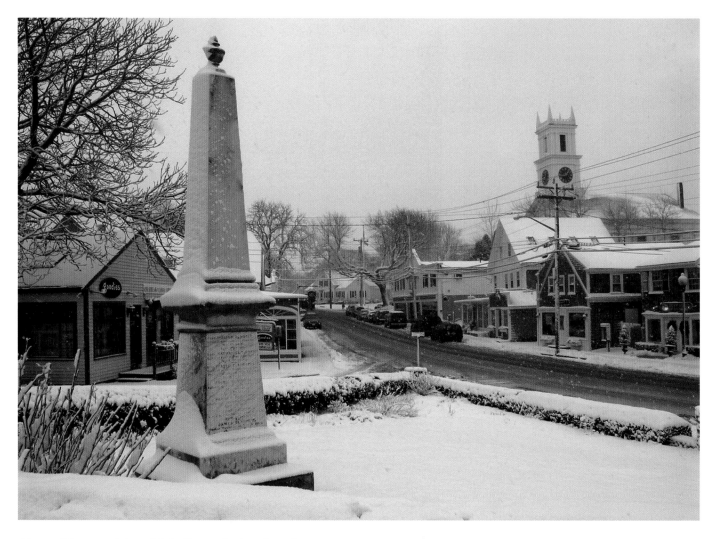

Above: It's peaceful on Main Street during the winter.

Right: Downtown streets are blanketed with snow after a blizzard.

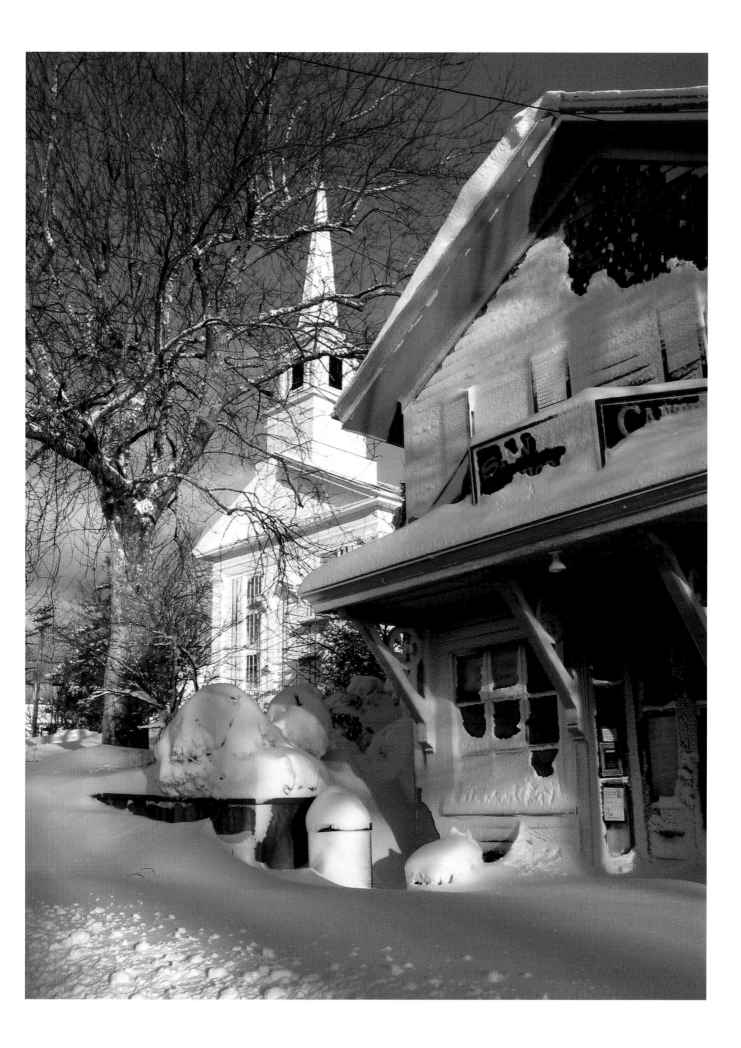

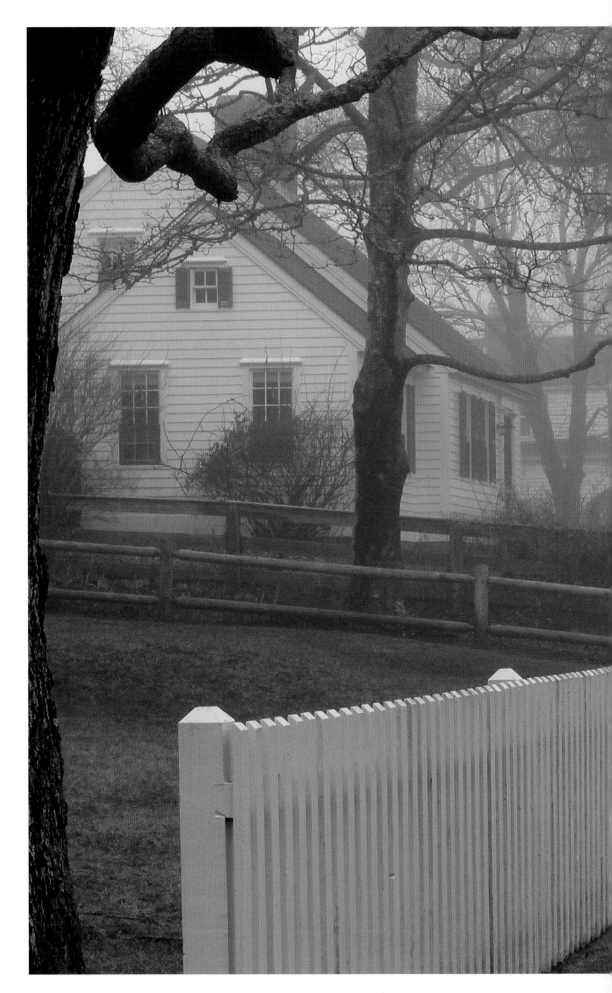

A foggy day on
Silver Leaf Road
in Chatham's
Old Village

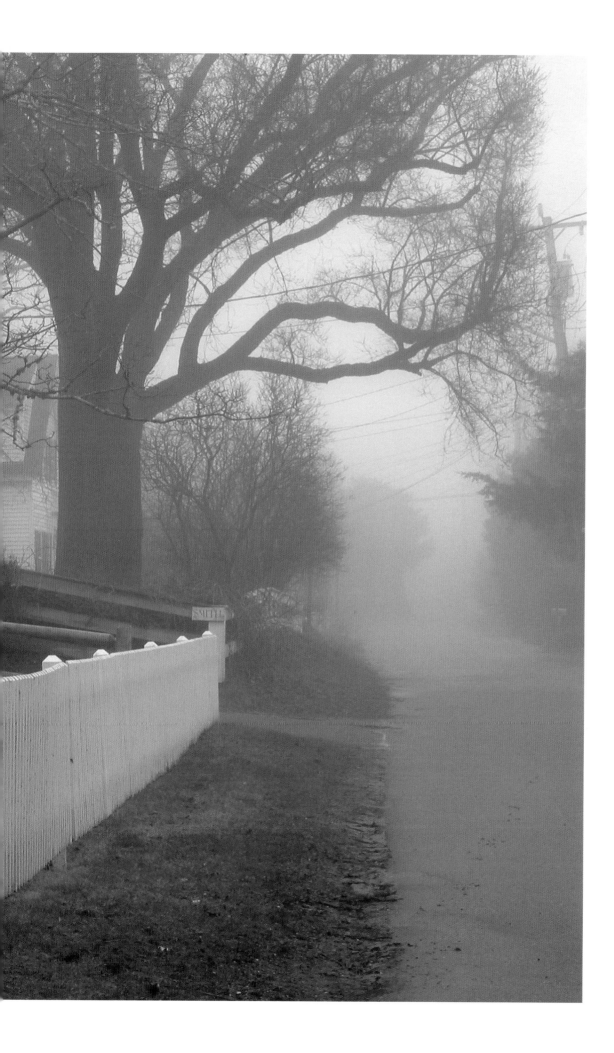

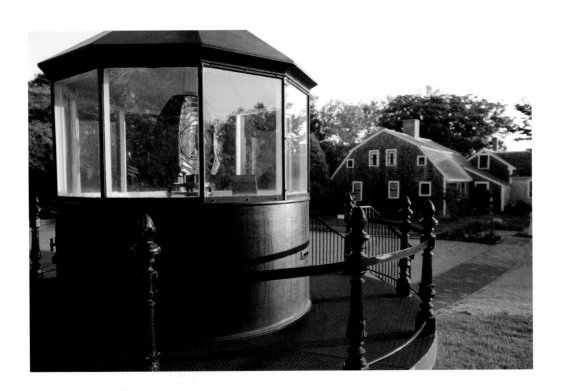

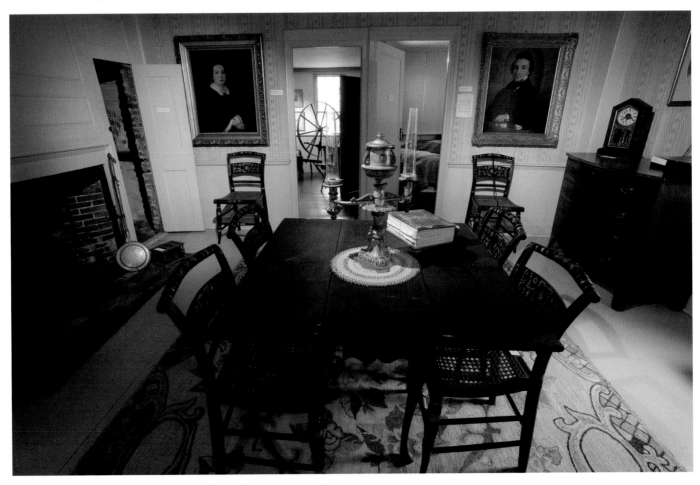

Above: In the nineteenth century, Chatham had two lighthouses set about 70 feet apart. The original light beacon from one of the "twin lighthouses" is on view at the Atwood House.

Below: The dining room in the Atwood House, a typical Cape-style house built in 1752

Right: A historic residence in Chatham's Old Village

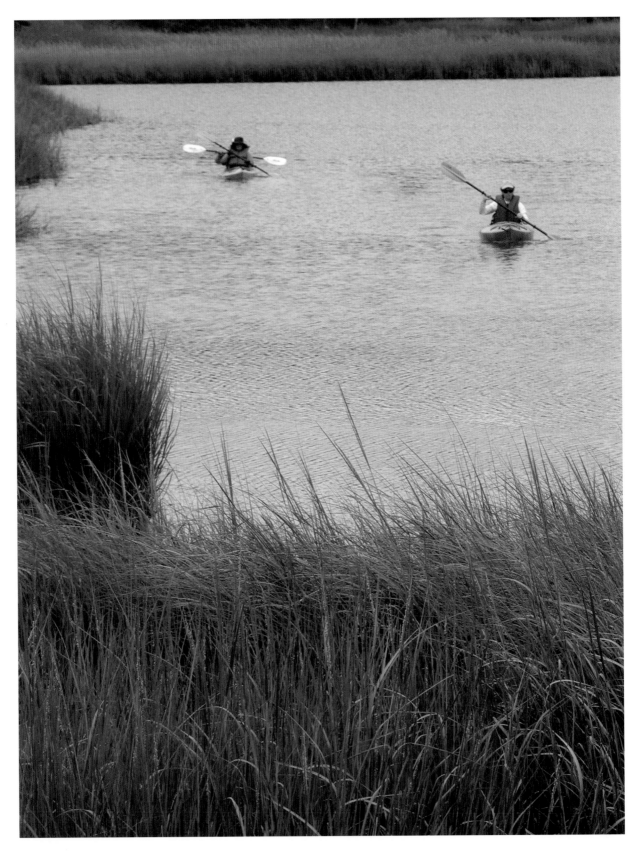

Above: Kayaking in Taylor's Pond

Opposite: Top left: Porch Chairs on Eliphamets Lane

Top right: The American flag and hydrangeas are common sights.

Bottom: Picket fences line the quaint village streets.

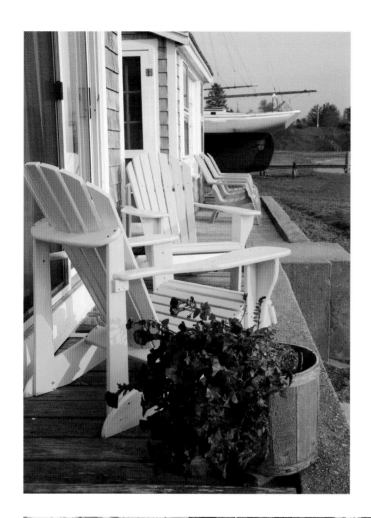

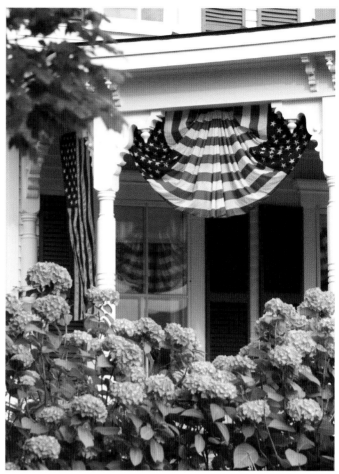

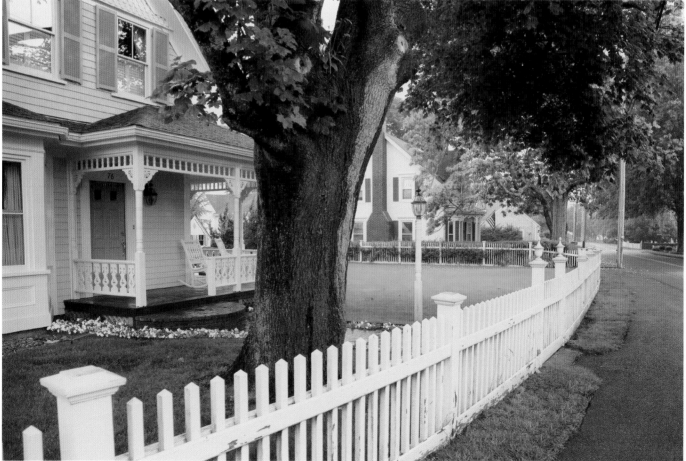

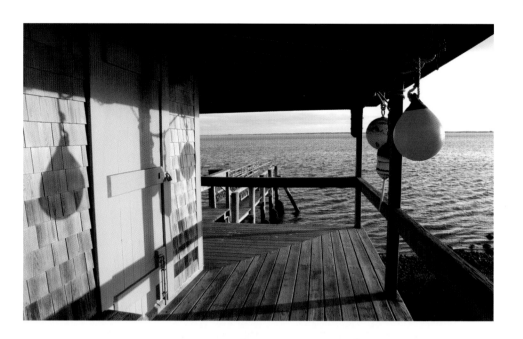

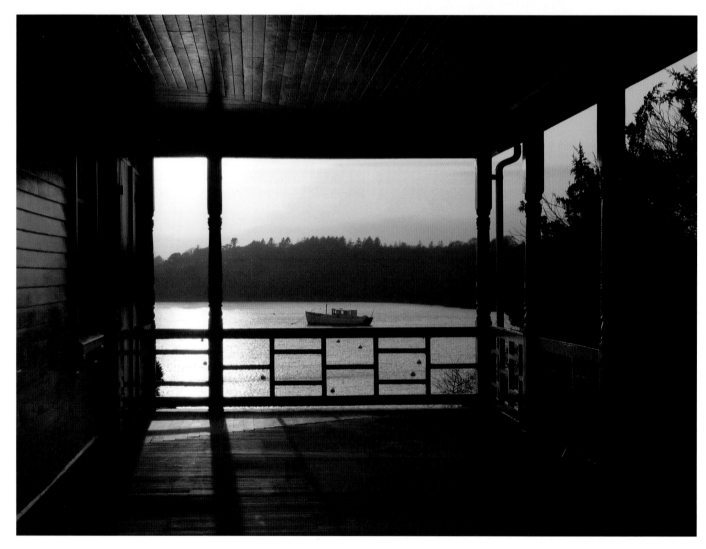

Above: Buoys on the boathouse

Below: Sun porch

Right: The Old Godfrey windmill was built in 1797 by Colonel Bejamin Godfrey to grind corn. Here it is decked out for the Fourth of July.

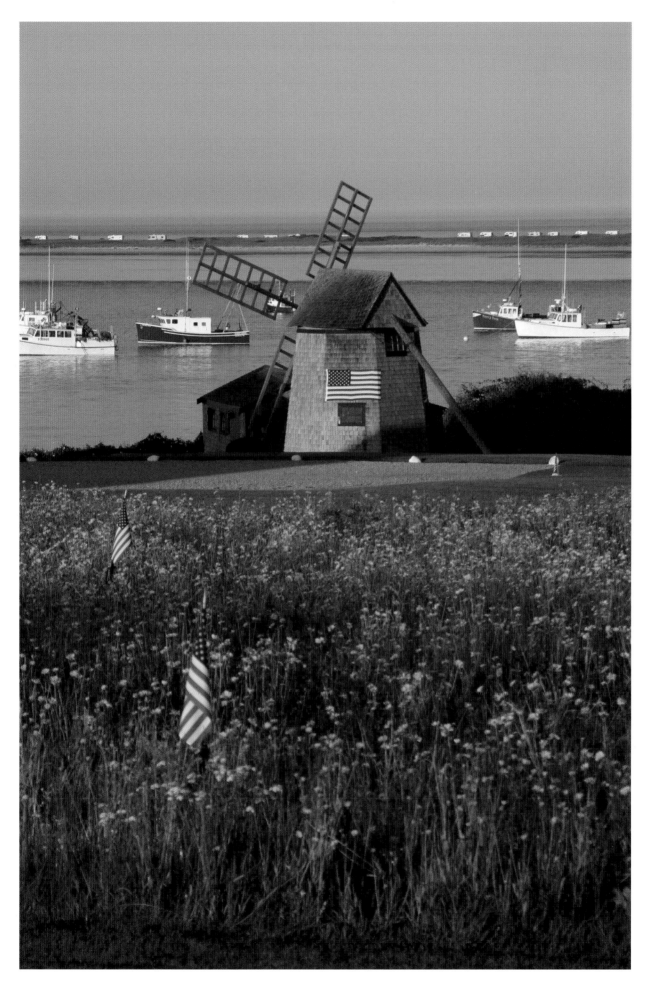

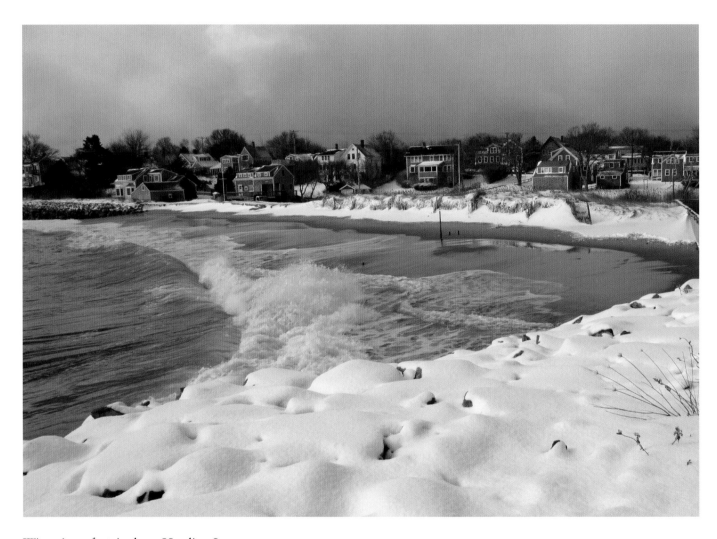

Winter's surf at Andrew Harding Lane

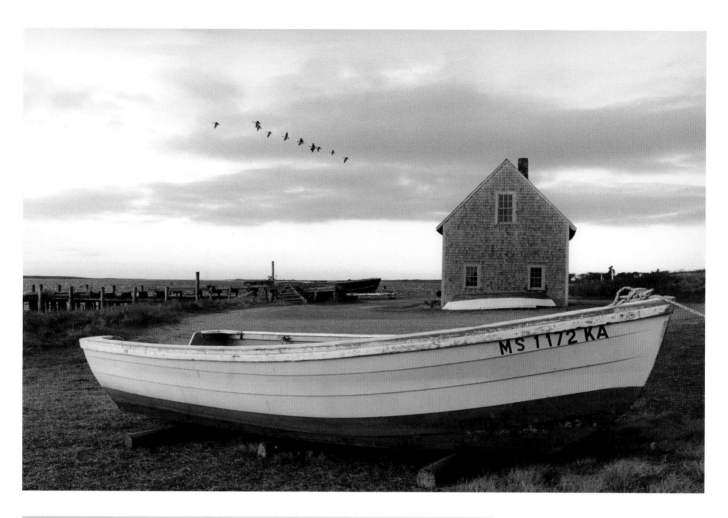

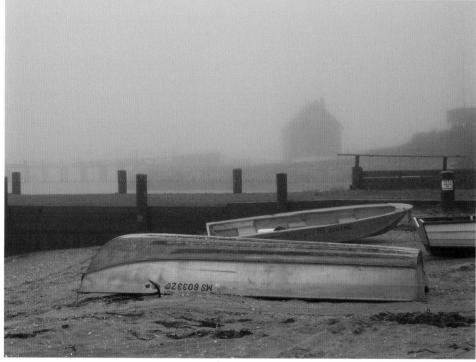

Above: The old twine shed on Port Fortune Lane

Below: Stage Harbor fog

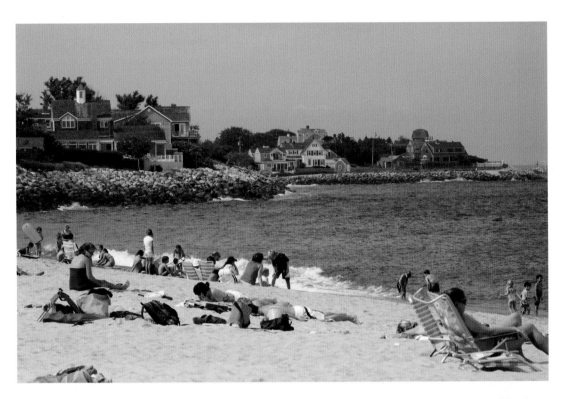

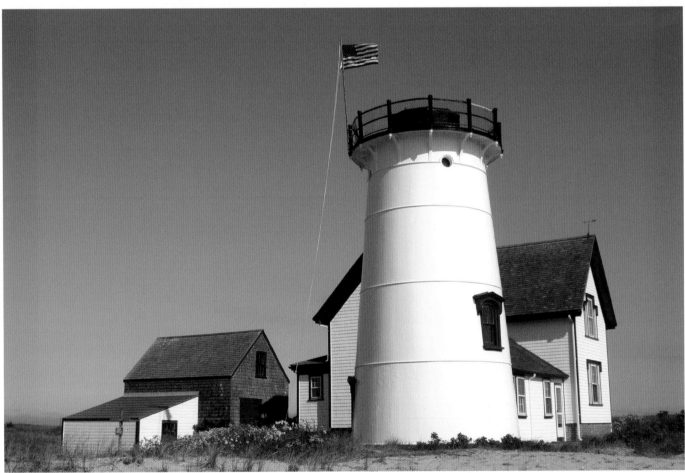

Above: Rock revetments line the shore beyond Lighthouse Beach.

Below: Stage Harbor Lighthouse on Hardings Beach

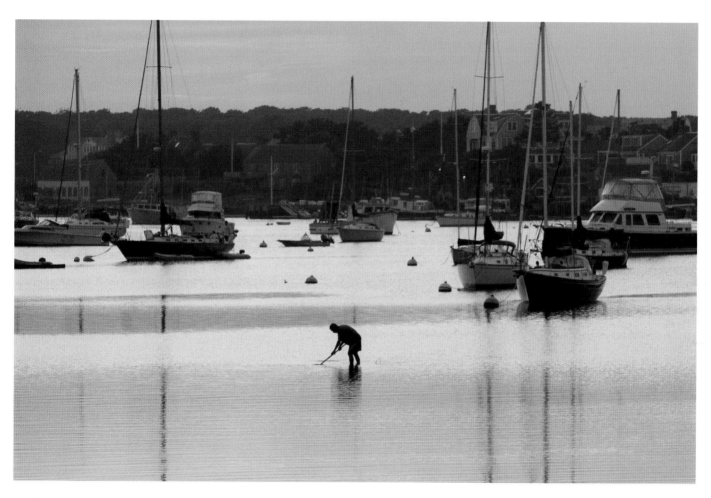

A clammer at Stage Harbor

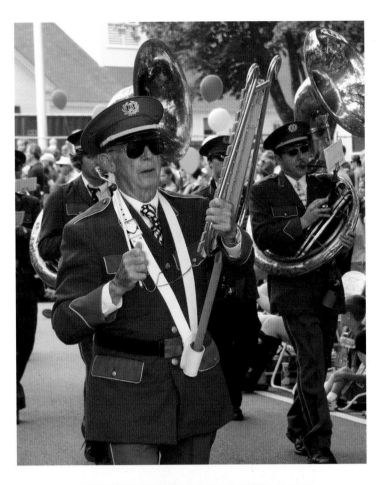

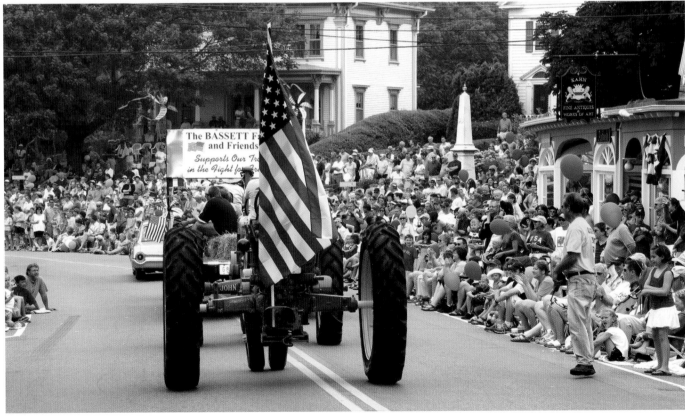

Above: The Chatham Band marching in the July Fourth parade.

Below: The July Fourth parade kicks off the summer season.

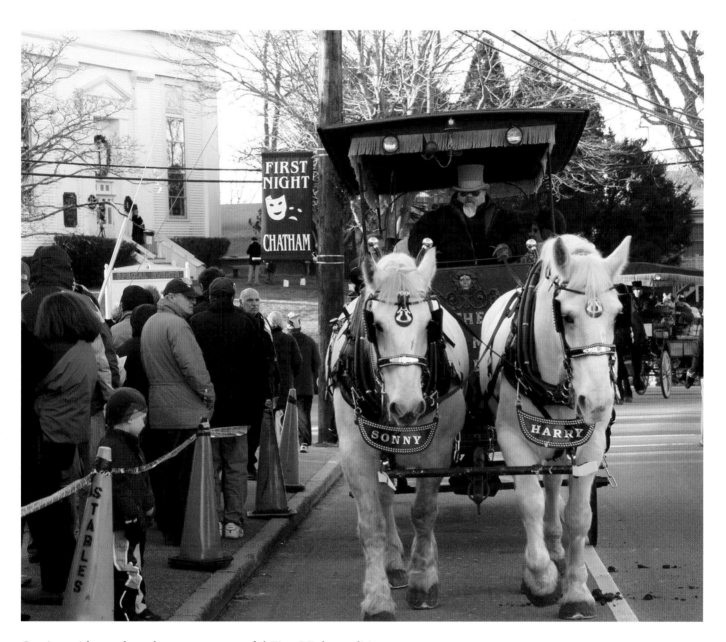

Carriage rides on have become a successful First Night tradition.

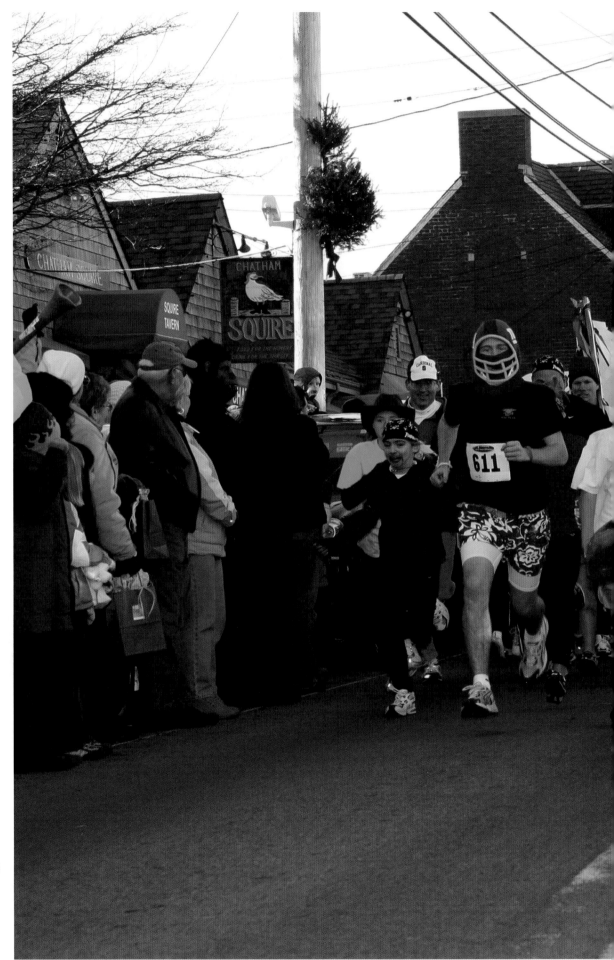

The Fun Run on
First Night.

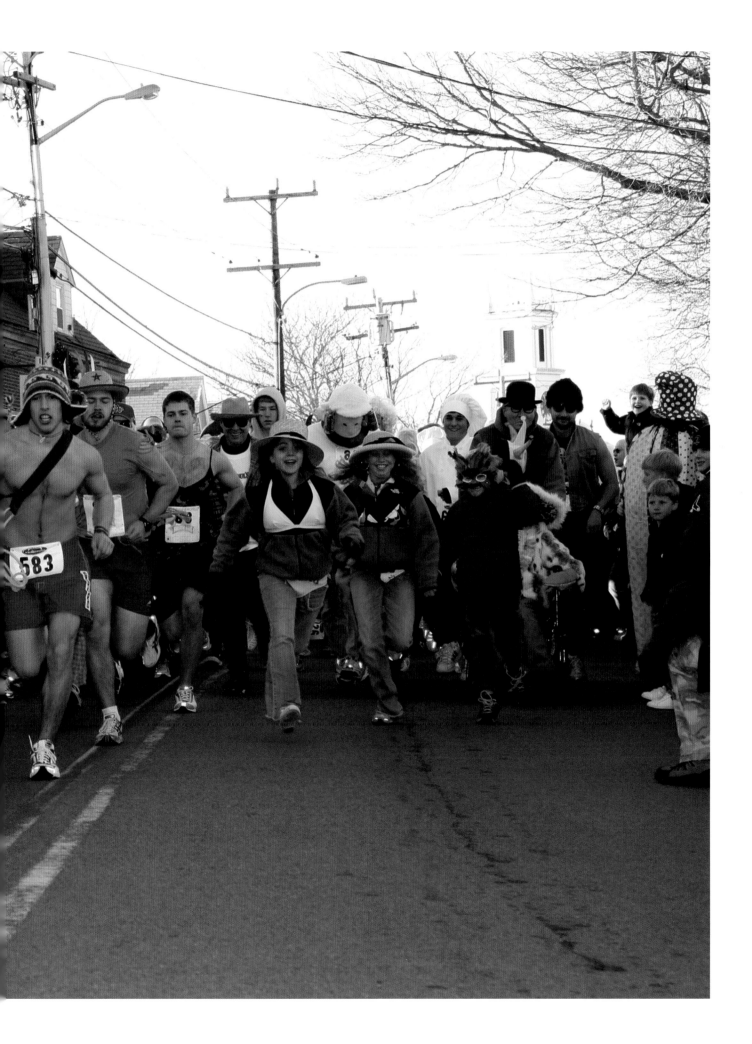

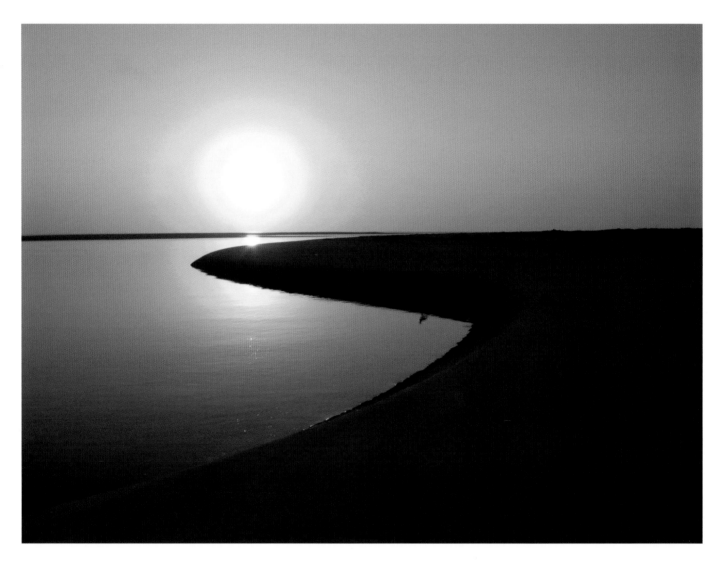

Sunrise at South Beach

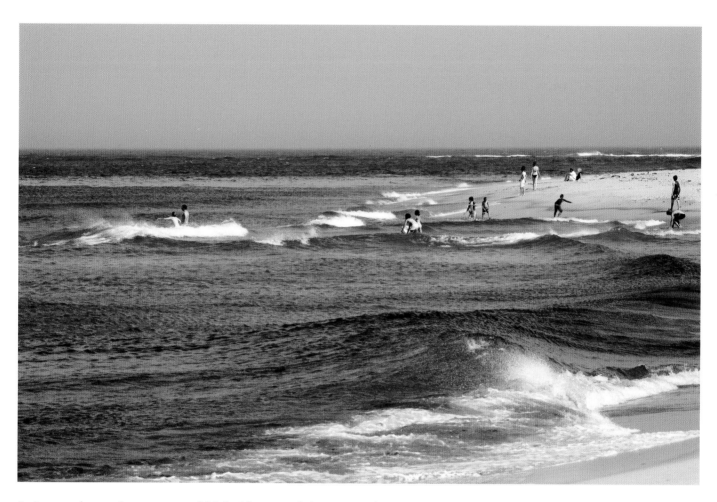

Swimmers brave the current and high tides at Lighthouse Beach.

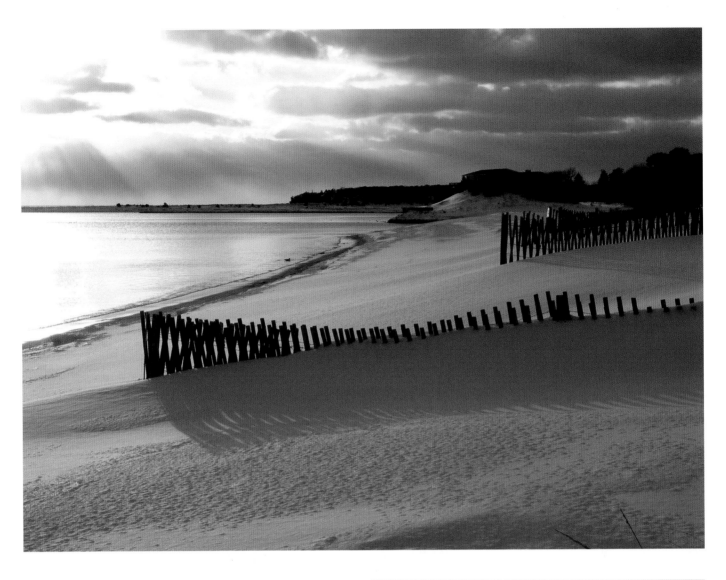

Above: Cockle Cove Beach is calm after a winter storm.

Right: Rose hip bushes add spots of color to Hardings Beach.

Far right: One of the two bridges that cross the march at Ridgevale Beach

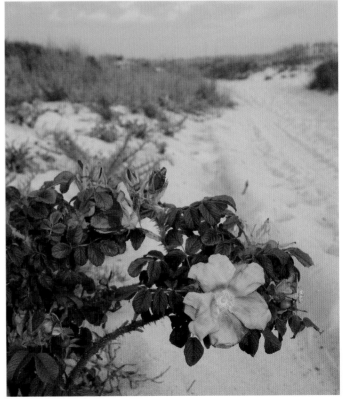

50

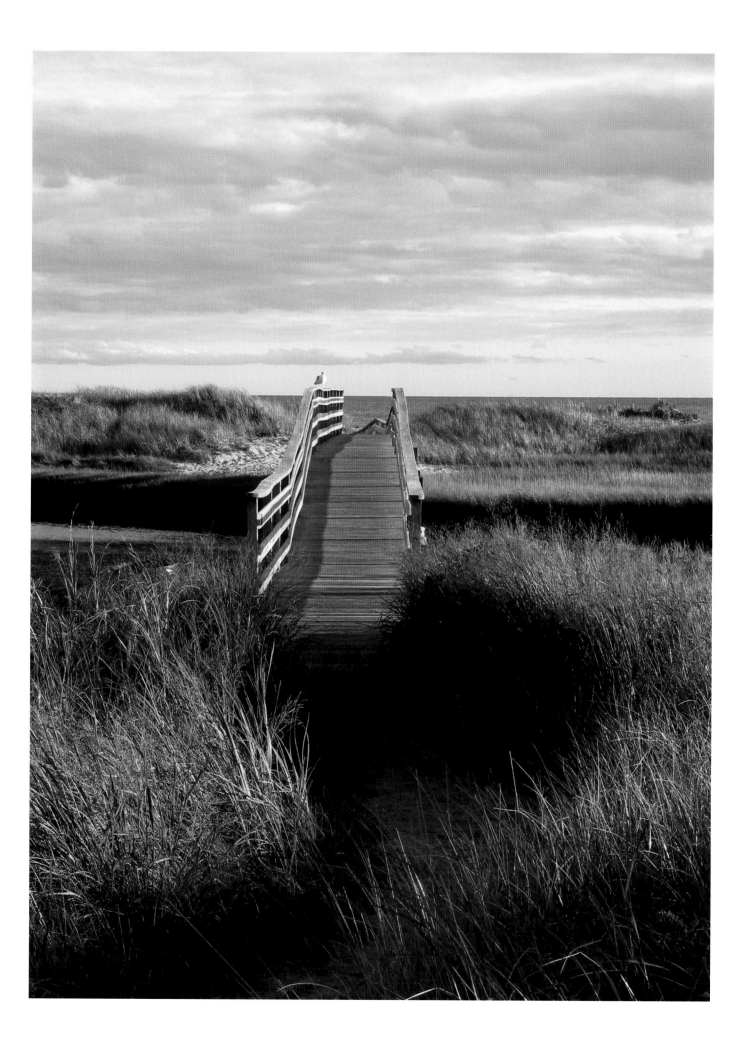

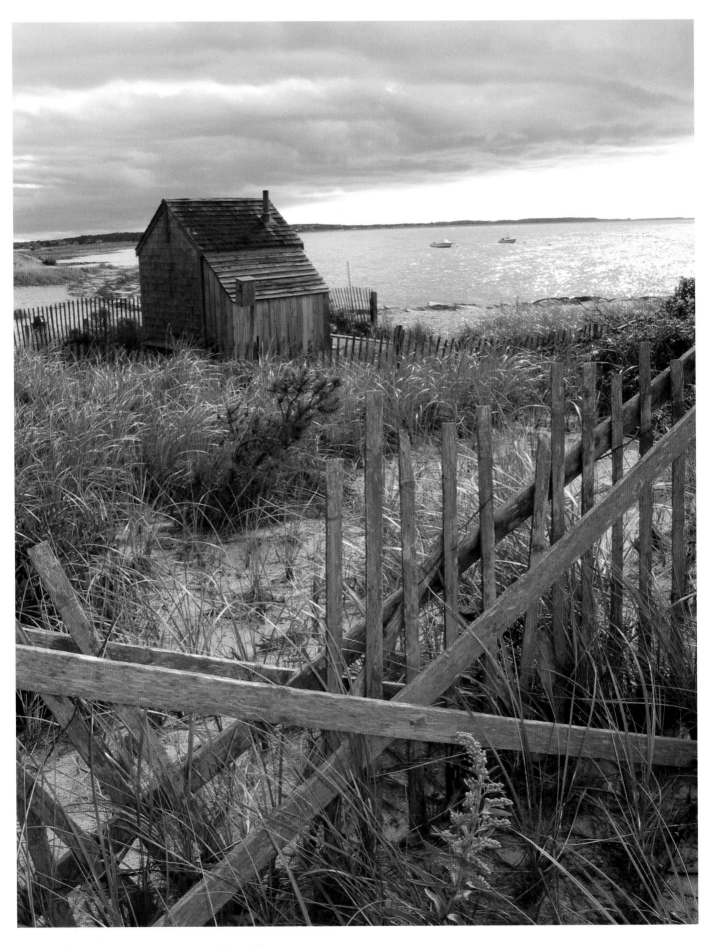

Baker's Shanty at Forest Beach Landing

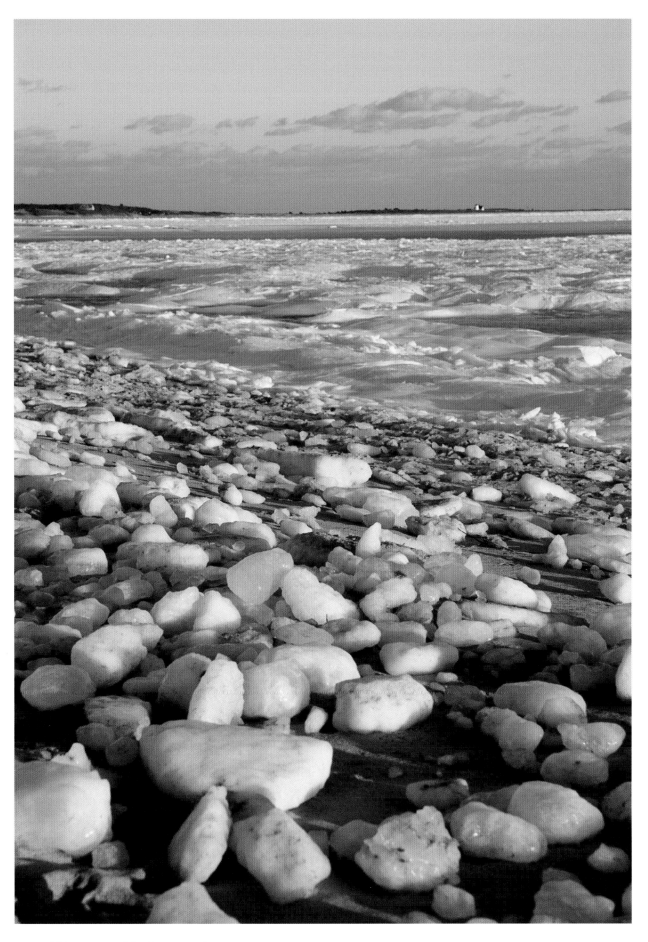

Ice pebbles on Cockle Cove Beach

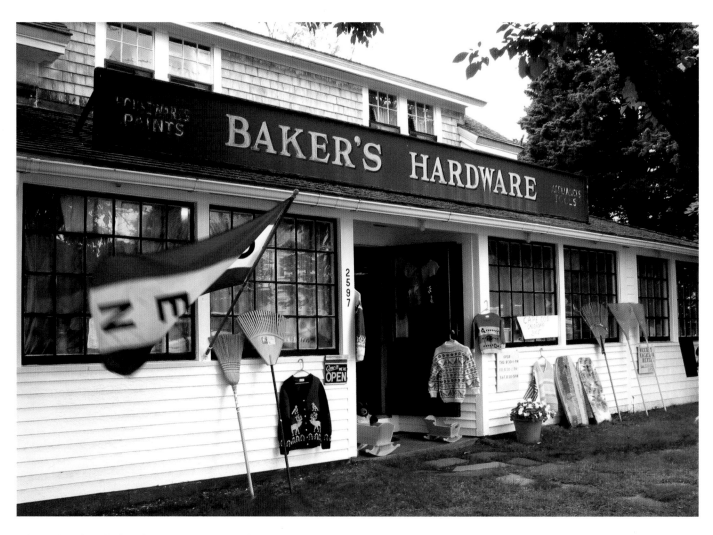

The Baker family hardware store in South Chatham is like a step back in time.

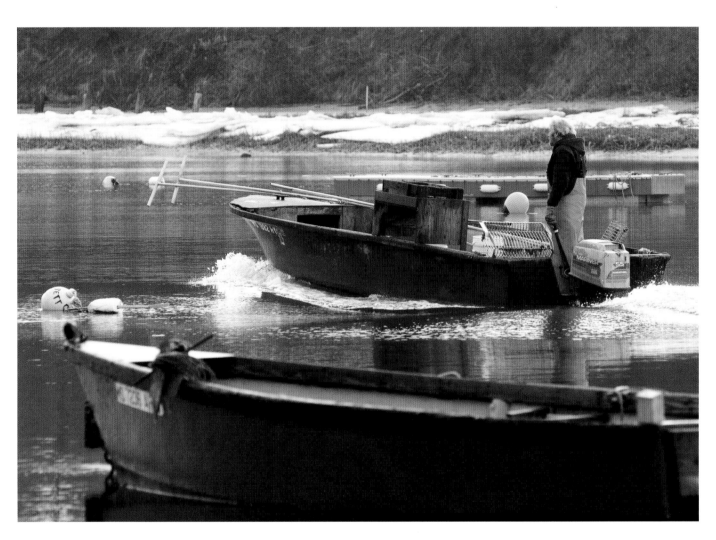

A long raker heading out for the day

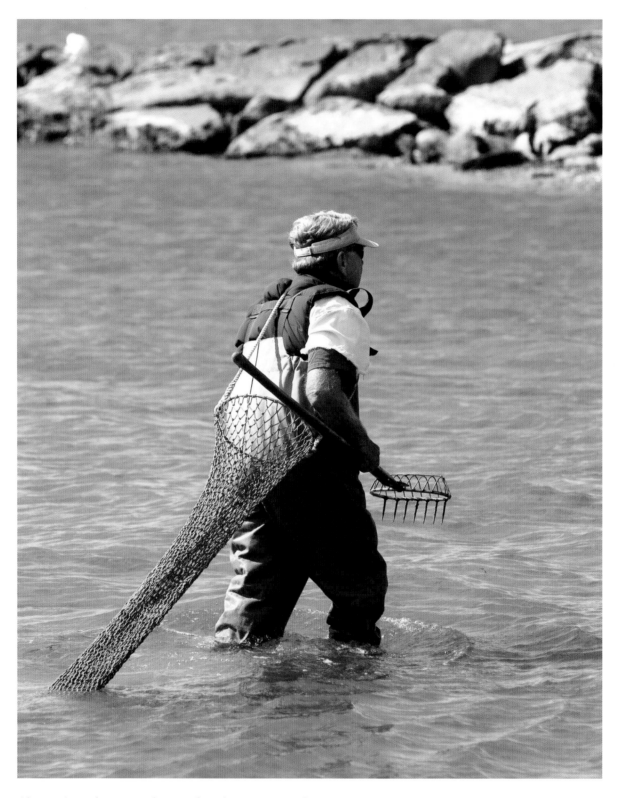

Above: A quahog scratcher catches the morning tide.

Right: A sailboat rests on the beach, waiting for the wind to pick up.

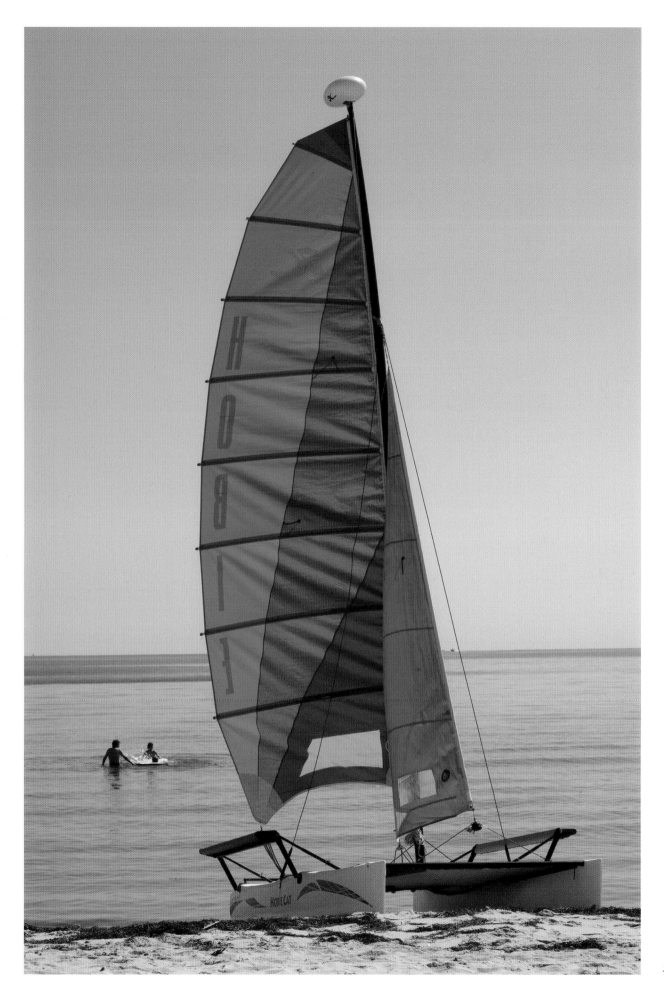

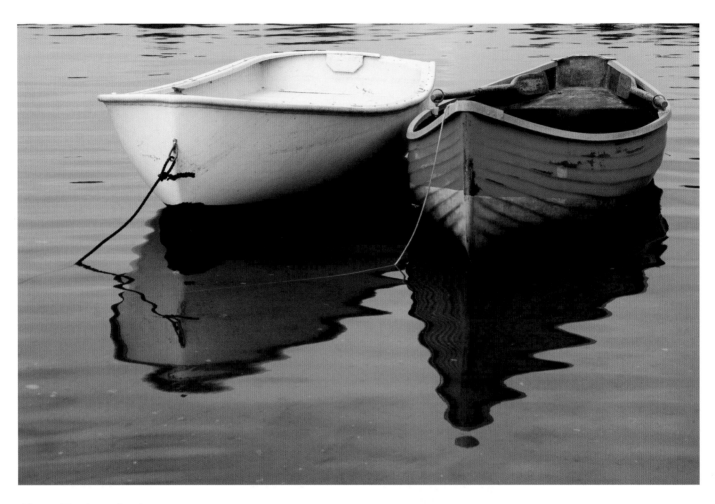

Above: Tender reflections

Right: A lifeguard stand at Cockle Cove Beach
after a passing summer shower.

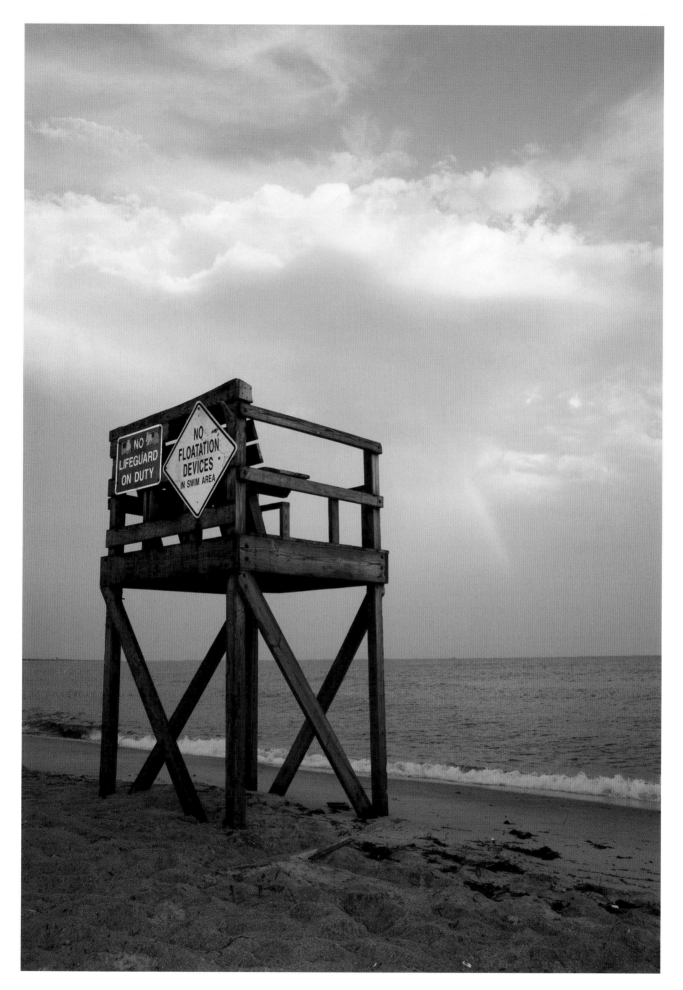

JENNIFER ELDREDGE STELLO

Jennifer Eldredge Stello, a life-long resident of Chatham, traces her roots back eleven generations to William Eldredge, who set sail from England to arrive in the New World around 1637. She acquired her creativity from her mother, a talented artist, and her father, an amateur photographer, former teacher, and school principal.

Jennifer first attempted to capture the wonders of nature when she spent several childhood summers traveling to and camping in most of America's spectacular national parks with her parents and brothers. During their hiking and canoe trips they photographed the vast panoramic vistas of our country's plains, rivers, forests, and mountains, kindling Jennifer's lifelong passion for landscape photography.

At Green Mountain College in Vermont, Jennifer had the opportunity to photograph the splendors of fall colors and winter's snow-capped mountains. On weekend getaways and school vacations she would return to Chatham and her favorite scenes of the Chatham Fish Pier, Monomoy Island, and her secluded family camp on North Beach. Returning to Chatham after college, she married Robert Stello, also a native of Chatham. Her first job was designing window displays at the Chatham clothing store Mark Fore & Strike. Later, she worked for the design department of Puritan Clothing, traveling to their eight locations on Cape Cod. Her artistic flair for composition and color in retail merchandising is now reflected in her classic images.

Jennifer's interest in child and family portraiture began with the arrival of her two children. She soon realized that capturing a child's each and every expression was a talent that she wanted to master. Skills developed and she was rewarded with the appreciation of parents who saw precious moments of their children's early years frozen in time for future memories. "Capture the Moment" has become Jennifer's motto.

In August 2003 the importance of this motto became clear to Jennifer and her family with the tragic loss of her son Joshua, age 25, in an auto accident in California, changing the lives of Jennifer and her family in an instant. The moments she had captured on film, from crib to adulthood, are memorialized in her family photo albums. Her son's passion for life is the backbone of Jennifer's drive today.

Jennifer is now recognized for her family beach photography. To get the perfect light, she schedules sittings on the dunes an hour before sunset. Being spontaneous with the children and giving them the freedom to be who they are creates a special moment on film. Her diverse career extends to wedding photography and freelancing for the *Cape Cod Chronicle*. Off season she works with her daughter, Brianna, a well-known photographer in Charleston, South Carolina. Mother and daughter collaborate on large weddings, special events, and commercial photography. Any time of year, if you are an early riser, you're likely to see Jennifer walking with her camera and tripod through the peaceful streets of Chatham's old village capturing the morning light, or scooting around in her boat cataloging shifting sands, fragile beach shanties, and the local fishermen.

Jennifer has been fortunate to photograph many of the world's beautiful locations. But when the trip is over, the beach sand that is stuck in her shoes tickling her toes lures her back to her favorite place, the one she calls home: Chatham!